目錄

推薦序
Introduction

/翻譯 Nina Edwards

范赫鑠
Frankie Fan

從學生時期就認識羅羅接近 20 年載，羅羅自小師承名師，她繪畫的才華在學生時期就已經展露，並且散發著強韌與神秘的色彩。羅羅是個勇敢追求自己喜愛與夢想的人，在畢業後也選擇了與同學間不同的路，惟一不變的是始終誠摯的面對自己的心與身邊交會的朋友。

I have known Florence Lo for 20 years, since we were students. She has studied with renowned teachers since she was young. Her talent in drawing emerged when she was a student, a talent that seemed both robust and mysterious. Florence is someone who dares to pursue her own interests and dreams, and chose a different path than her classmates after graduation. The one thing that has remained constant is her sincerity towards herself and her friends.

羅羅的每一次蛻變或說是生命中的轉折，似乎就像是為了蛻變而蟄伏、準備並且蓄積了許多生命能量後的選擇與結果。不管是投身於兒童繪本手繪藝術，展現鮮明的圖像風格，或是這一次的再蛻變，「遊走荒謬」這系列的畫作的切片與脈絡紋又可以觸探不同的生命力。這次的蛻變，投射出她對社會環境的觀察、都會女性所面臨的家庭與追求等等的心路歷程刻畫。這次蛻變背後的觀察與投射，更加的擴大了她與不同的社群族群間的共鳴與對話。

Every time Florence has transformed, or reached a turning point in her life, she has appeared to hibernate in order to transform, reaching her decision after preparing and conserving a lot of life energy. Whether she is engaged in displaying her distinctive drawing style through hand-drawing childrenís picture books or engaged in the sections and vein patterns of her current re-transformation ñ the Walking Absurd artwork series ñ one can sense and explore the different forms of life energy. Her current form expresses her observations towards society and the environment, as well as the mentality characterized by metropolitan women who face family issues, demands and so on. The observations and expressions behind this from further emphasize her resonance and dialogue with different societal groups.

繪本藝術在當代已屬顯學，大量圖像式的直接傳達，印刷文本的手感也使得閱讀者擁有更多豐富的介面經驗，使得繪本藝術突破年齡層開展一條嶄新的脈絡。繪本藝術家在當代藝術發展的議題中，不易切割為單獨的單元或個體，平面藝術，也必須考量動態的互動關係，因此繪本的發展很自然的就會與影片相互連結。現今的繪本已經注意到使用者對於閱讀傳達之間的關係，從單張發展為連續文本式，甚至是線性與非線性的形式，也使得繪本藝術家必須對於電影文本必須有一定的了解。羅羅在繪本創作上，洋溢著許多拼貼、重製、場景式甚至是多重文本式的風格，也使得羅羅的繪本有著明顯的張力。

Picture book art is a well-known area. The direct form of communication achieved via large volumes of drawings, together with the medium of printed text, gives readers a richer interface experience, enabling picture books to cut across age groups and chart a brand new path. The development of picture book artistsí in contemporary art cannot be easily divided into single units or individual topics. Graphic art must also consider the interactive relationship of motion; therefore, the development of picture books is very naturally linked to film. Picture books today have already recognized the relationship readers have with the messages that they read; therefore, they have developed from single drawings to continuous text forms and even from linear to non-linear styles. This has also forced picture book artists to have a concrete understanding of film texts. Florence fills her picture books with many collages, reproductions, scene styles and even multiple text styles, also creating a distinct tension in her picture books.

在水與彩的媒材，台灣地處亞熱帶，有別於高緯度的寒帶國家，羅羅的濃麗色彩呈現出台灣亞熱帶地域性風格，用色注重瑰麗、有如陽光般的強烈色彩感受。在創作的風格上，羅羅鮮明瑰麗的色彩風格，加以她獨特的拼貼、重製、電影文本式的創作，以及對於都會女性議題的觀察與刻畫，使得羅羅的創作產生非常不同的現代風格，並對於不同的社群產生特殊的共鳴感與吸引力，甚至對於閱讀者的產生魔力與想像空間。我也期待羅羅的再蛻變。

In terms of watercolor media, Taiwan is situated in the subtropics. In contrast to the colder countries of higher altitudes, Taiwanís subtropical regional style is expressed through Florenceís use of lush and bright colors, which focuses on magnificent colors with the strong and colorful feeling of sunlight. In terms of her creative style, Florenceís bright and magnificent color style combined with her unique works of collages, reproductions, and film text, as well as her observations and characterizations of metropolitan women issues, result in a very different modern style for Florenceís works. It has a special resonance and attraction towards different societal groups, stimulating the imagination of readers with its magnetic attraction. I too, look forward to Florenceís next transformation.

交域互動科技設計公司總經理｜范赫�
Frankie Fan
xXtraLab Design CO.General Manager

推薦序
Introduction

/翻譯 Nina Edwards

王正德
Woody Wang

羅羅請我為 2014 年「遊走荒謬」跨界個展的畫冊寫序，我倍感榮幸。她說，過去幾年是一趟探險之旅。

It is my great pleasure to write an introduction Florence Lo's first solo exhibition: Walking Absurd 遊走荒謬. She tells me that the past few years has been an adventure for her.

還記得第一次和羅羅見面，她送了我一張卡片，上面印有她的插畫，畫中有個小女孩拿著畫筆攀上樹梢彩繪著。當時的我被這幅深具童話色彩的插畫吸引，卻還不大明白畫裡面的精彩故事。漸漸認識羅羅之後才明白，她的作品就和她的人生一樣，都有耐人尋味的故事。

I remember when I met Florence for the first time. She gave me a card featuring her illustration: a little girl holding a paint brush climbing to the top of tree. I was captivated by the fairytale style on the card but had no idea about the story behind it. As I grew more acquainted with Florence over time, I gradually realized that both her art and her life have many intriguing stories behind them.

羅羅的人生並非一帆風順，從小成長和學習過程幾經波瀾，生命歷程更比一般人多了許多曲折。可以想像，一個曾經放棄職業生涯的藝術家，十餘年後人生際遇選擇再度復出，一時之間沒有任何資源，一切靠自己從零開始，多麼難能可貴。羅羅復出重新創作，有時是孤獨和無助的，付出與收穫不一定成正比，想必吃足苦頭。更難得的是，羅羅身兼自己作品的代言人，除了創作，也一手包辦策展與媒合的工作，這對於一般創作者而言，更是艱鉅的挑戰。如此的堅持，外人看來可能只為執著，卻是羅羅完成自我生命詮釋的必經歷程。因為在羅羅身上，我看見一個經過淬煉的靈魂，在生命最幽暗的一頁裡，她勇敢選擇自己的道路，用心看見自己，發現真正的東西，就像她的作品 <微光>，在生命時間的走廊裡，必須拂去塵埃，才能看見屬意的光。

Florence has a humble past. While growing up, she encountered many difficulties with her school, family, and career. Many events conspired in her life to ultimately suspend her career for over a decade; she was finally able to start over three years ago. She felt lonely and helpless when she finally resumed her career, and initially she saw few gains for many pains. Moreover, Florence often had to be agent, curator, and artist, which presented a big challenge to her. However, Florence's persistence and devotion are not just obstinance, as others might think, but a process for self-fulfillment. As in Florence's artwork "Glimmer 微光", after the dust is wiped off comes brilliance. I see a spirit in her that time has tempered. It leads her to choose her own way, explore her true self, and discover the essence in the darkness of life.

值得開心的是，當她選擇重新與心靈天賦開啟對話的那一刻起，似乎註定有更多懷抱夢想、不甘寂寞的靈魂，會陪著羅羅一起完成這趟探險之旅。所以，儘管創作過程是孤獨的，但羅羅透過她的作品，一步一步開啟更多的對話。她透過繪畫，開啟與建築、歷史、土地的人文對話；她透過藝術的整合，開啟與空間、電影、音樂、手作、商品、多媒體、商演的跨界對話；她透過繪本、工作坊和講座，開啟與孩子們的藝術對話。

Fortunately, once Florence decided to apply her talents completely, she felt destined to venture into the art world. And she is not alone; she is accompanied by her dreams and soul. Therefore, Florence was not alone when creating these pieces because her works opened dialogues with people. She communicated with architecture, history, and culture through her works in a humanistic way. She integrated her art into a conversation among space, movies, music, crafts, merchandises, multimedia, and commercial performance. Through her illustrated books, workshops, and lectures, she even opened a conversation with children.

「遊走荒謬」是一個里程碑，展覽集結了羅羅近年來最精采的創作主題系列，透過精湛的彩繪技法，融合了類似後現代、抽象畫、浮世繪等多元的風格色彩，創造出異想的世界與人物，試圖勾勒出自我反身性思考以及對人我社會的凝視與批判，每一幅作品都堪稱嘔心瀝血，背後的故事更值得細細咀嚼、慢慢品味，因為每次重新看待，彷彿都會從細節中發現「意外的收穫」。更難得的是，德不孤必有鄰，羅羅的努力，讓電影、音樂和設計界的大師和前輩們都願意跨刀相助，讓這次的跨界個展倍有看頭。

As a major milestone for Florence, this solo exhibition presents the best of her recent work. Her sophisticated drawing skills mixed with postmodernism, abstract and Japanese ukiyo-e styles make a virtual world of illusion and persona. Through these works, she tries to outline a reflection on individuals and a critique on groups. Florence made best efforts to every single piece with full pleasant flavor to savor, and there is always a pleasant surprise if one views it again and examines the details. Praiseworthy, her hardworking virtue attracts many masters from the movies, music, and design industries to participate, all of which makes this an exhibition to look forward to.

最後，我期待羅羅未來能有更多的作品問世，在這個虛幻的世界裡，透過藝術本質的創作，為給人們帶來更多真實的探險。我想借用動畫家華特迪士尼的話，與羅羅共勉之：「繼續前進，打開新的門，嘗試新的事物，好奇心永遠會指引我們新的道路。」

Lastly, I look forward to Florence's work in the near future, which will lead people to more real adventures through the essence of her art in the unreal world we live in. I would like to share the words from Walt Disney with her: "We keep moving forward, opening up new doors and doing new things, because we're curious...and curiosity keeps leading us down new paths."

中國科技大學數位多媒體設計學系講師｜王正德
Woody Wang
China University of Technology Department of Digital Multimedia Design,Lecturer

RESUMES

作者簡介
————————

簡歷

華岡藝術學校美術科第一屆畢業。師承吳昊（東方畫會成員）、楊恩生(知名生態水彩畫家，深受楊老師影響)、吳承硯（前文化大學美術系教授）、李可梅(水墨)、巴東（現任歷史博物館副研究員兼研究組主任)以及龐均（知名油畫家）。從事藝術學習以及創作達30年，近年以插畫以及繪本創作為主，並跨界和電影、空間視覺設計、產品、動畫、多媒體和音樂創作結合。

創作理念

雖然長期受的是純藝術的薰陶，但選擇「插畫」這種創作形式更深入生活，特別對女性議題有深刻的感受與看法，此外更連結不同的藝術的可能性，試圖搭起作品、觀者、和創作者之間的互動。
創作的過程是孤寂和不安，但弔詭的是其作品常呈現一種溫暖和富有生命力的意涵，也許，是反映內心深層的渴望。創作者認為多元的生活體驗非常的重要，走入人群，才能找到這世代的語言，融合自己的生命體驗。

相關經歷

2012 鶯歌陶博館國際雙年大展《小象的冒險旅程》展場主視覺/繪本設計/聽繪本玩創作講師
2012 北京「我能給的天亮」王錚亮演唱會舞台情境插畫設計
2013 蘭陽博物館中日交流白金傳奇鰻魚特展《小鰻魚來了》展場主視覺/繪本/聽繪本玩創作講師
2014 電影「他媽媽的藏寶圖」場景插畫設計
2014 宜蘭文化局 羅東文化工場插畫課講師
2014 宜蘭國際藝術節「跳跳村創作繪本館」參展藝術家
推廣<聽繪本玩創作>課程

展覽

2013/10 台北安和65國際貓插畫聯展 (安和65)
2013/08 繪本<七月尾>新書發表 / 宜蘭音樂圖文專輯<宜蘭的風> (李國鼎故居)
2013/07「意識跳格」聯展 意境畫廊
2015/05「遊走荒謬」跨界個展-當現代超跑遇上當代插畫(豐群汽車)

作品/繪本收藏
慕尼黑國際少年圖書館
澄波藝術文化股份有限公司
何歡劇團

良品月子中心
魚可國際顧問公司
等 及私人收藏

客戶
新北市政府
宜蘭文化局
鶯歌陶瓷博物館

蘭陽博物館
早苗智作公司
良品月子中心

得獎/入選
2011 繪本〈放假囉！〉獲國家出版獎
2012 插畫設計市集310/三采文化

網站/粉絲頁
彩繪希望工作室
http://www.facebook.com/PaintedHopeArtStudio
www.heyshow.com/browsing/21498
http://www.behance.net/FlorenceLo

FLORENCE LO

Biography

I was graduated from Taipei Hwa Kang Arts School ,Taiwan ,in 1990, spent the first 15 years focusing on watercolor. During this time, I work with some well-known artists, also learning Chinese Ink Art, oil painting and design. I spent the latter 15 years in illustration art.

Growing from my core ability, now combining visual, spatial, music, animation, film, and products. I wish to expand my work horizon to a new level. In the past, I also had quite a few custom order arts requests.

Creative Concept

Growing up learning fine arts, eventually I choose to do illustration. It's easier in this style to reflect life's issues and connect with other artists by promoting interaction with artists and exhibition visitors.

The time to create arts is pretty isolated with a lot of anxiety, but the works turn out to be with warm vitality, so I think it's reflecting to what my inner self really wants.

Many people ask me where I get my inspiration from. The strange thing is the more I seek, the less I have. Perception in our daily lives gives me the most, just let it happen naturally. Also to experience a wide variety of social circles is the key to obtain the inspiration. Walk among the crowd, talk to them, find out the current social topics, and then incorporate into my art work.

Projects

2012 Picture book 'Little Elephant Adventure ' and main visual for Taiwan Ceramics Biennale Ceramic Vision' in Yingge Ceramic Museum In New Taipei City

2012 Beijing concert 'Reno Wang' scene main visual

2013 Picture book 'Coming the Young Eels!' and main visual for 'Platinum Legend Eel Expo ' in Lanyang Museum

2014 Works 'Absurd' for Film' The Map of DNA' film's scene illustration design

2014 Yilan County Cultural Affairs Luodong Culture Working House Illustration Instructor

2014 Yilan International Festival 'Hopping Village Picture Book Museum' Artists

Exhibition Tour

2013/10 'International Cat's Festival' Joint Exhibition in Anhe65, Taipei, Taiwan

2013/08 Picture book 'The Moon Lantern Festival' and the album 'Yilan's Breeze' press conference in Kwoh-Ting Li's residence.

2013/07 'Action III ' Joint Exhibition in ARTDOOR Gallery, Taipei, Taiwan

2014/05 Walking Absurd Illustration Exhibition in Top Auto,Taipei,Taiwan

Collection

International Youth Library München, Germany

Ho Huan Drama Society

Cheng Po Arts and Culture Co. Ltd

WeConquer International Consultants Co, Ltd

Liang Ping Post Maternity Care Center

Private collections

Award

2011 Picture book 'Holiday' won National Publication Award

2012Masterpiece of Illustration/Sun Color Culture

Related Web Site

http://www.facebook.com/ PaintedHopeArtStudio

http://www.behance.net/FlorenceLo

http://fandora.tw/user/502332c57729b33e3c00688d

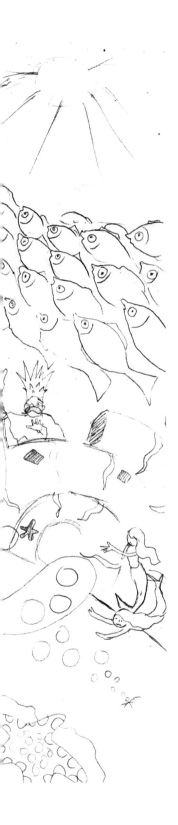

遊走荒謬創作理念

很多時候，看似安穩平凡的的生活 ，其實背後潛藏了很多暗流，因為大家對「改變」這件事常持著莫名的恐懼感，所以寧願戴著面具繼續過原來的日子、選擇漠視心裡真正的聲音 。然而，壓抑，只是讓內在的反彈更大罷了。

整個社會彷彿是一座大的時間工廠，人們在自己的崗位上努力過日子，因為科技的發展進步讓生活更便利了，人與人之間似乎溝通有無 ，但即便肩並肩在擁擠的車廂裡，疏離感便成為那空間一種既定的氛圍。物質條件提升了，但心靈層面卻低落。也許是無奈、無力，或無感，也已經忘卻了曾經在生命中一些無數平凡的小感動、所串連起一個美好經驗的珍珠項鍊。

大從社會、小至家庭到個人，如何和群體互動？如何和心理對話？甚至是生存的環境？這些問題都各個存在相對應的關係中。此次以’遊走荒謬’為主軸，，探討人與人之間的各面向，親情、愛情、夫妻和女性等在現代存在的位置。「空白」、「斷層」對一個生命體來說才是令人害怕的事，選擇默視？選擇勇敢的站出來？似乎是一件麻木現代人的生活下，值得思考的問題。

Behind The Scenes of Making The Walking Absurd Illustration

What seems to be a stable and quiet lifestyle is camouflaged by an extreme dangerous rip current. Since many people have this unknown fear to 'change', we'd rather not rocking the boat but to stay on our own destructive course. We often choose to ignore the calling to develop and grow, until it is too late...

As I see it, we all live inside a giant time machine, each of us mans our own little station. Technology advances our lifestyle, but does little to improve our interpersonal communication. We pass by each other inside this crowded machine everyday, and a cold alienation feeling frequently looms in the air. The more material stuff we own, the less we have in our souls. Can you still remember once upon a time our childhood experience of excitement and wonder strings into a shining pretty pearl necklace?

So how do we start this group interaction with another individual? Another family? with our neighbors? How do you talk heart to heart with someone? How do you cope with certain stages in life? These questions are all echoed throughout this Walking Absurd Illustration. You will find topics on personal relationships, family, romance, couples, and feminism in modern society. The fear itself exists in the feeling of being alone, having a blank in relationships. Do you choose to ignore this fear? Or be brave standing forward to make a change?

遊走荒謬系列

WALKING ABSURD ILLUSTRATION

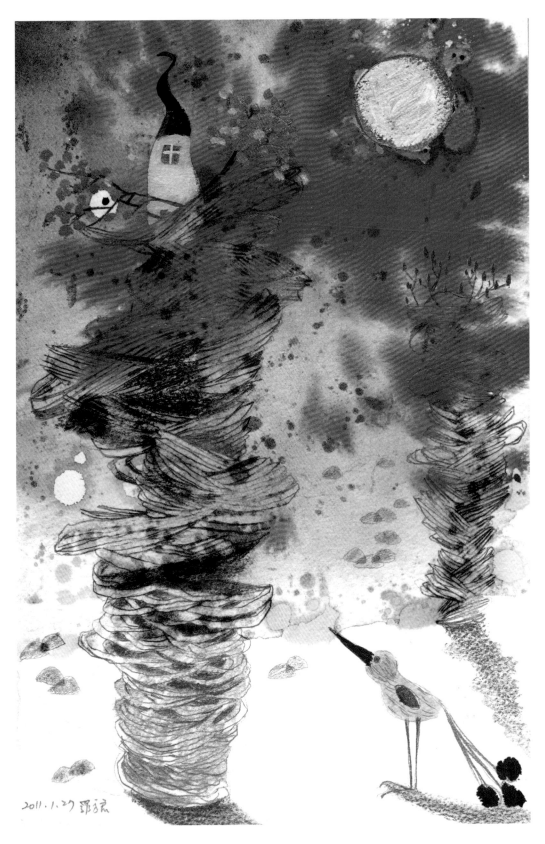

窩
HOME
2012
4K(37cm×45cm)

炭精筆・油・水彩
Charcoal Pencil, Oil, Water Color

層層疊疊
編織心中的夢
也勾勒遠方的家園
歎息 是座無聲的高塔
在落日餘暉下
永遠找不到它的斜影

Layers of woven dreams brought back a sense of home.
But it's in a far away distance, at an unreachable height.
I'm content only to see its shadow in the sunsets.

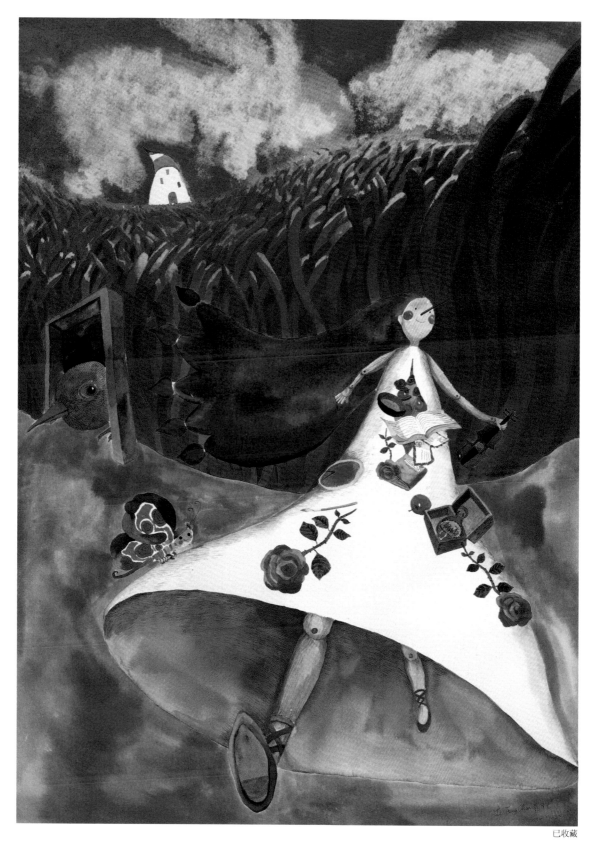

昂首闊步
STRIDE
2012
2K(45cm×76cm)

水彩
Water color

曾經埋首在腳底下的那塊陰影
卻忘了抬頭仰望日月星辰
和廣大無垠的天際
也許為了失落的一角
為了一段段浮光掠影的美麗
再次昂首闊步 勇敢前進

Focusing too much on your own shadow,
Then you're missing the twinkling evening stars.
Not letting the darkness to trap you in a corner,
But using it as a canvas to paint the silver moonlight!
Head up, chest out,
Taking a deep breath and marching on with pride!

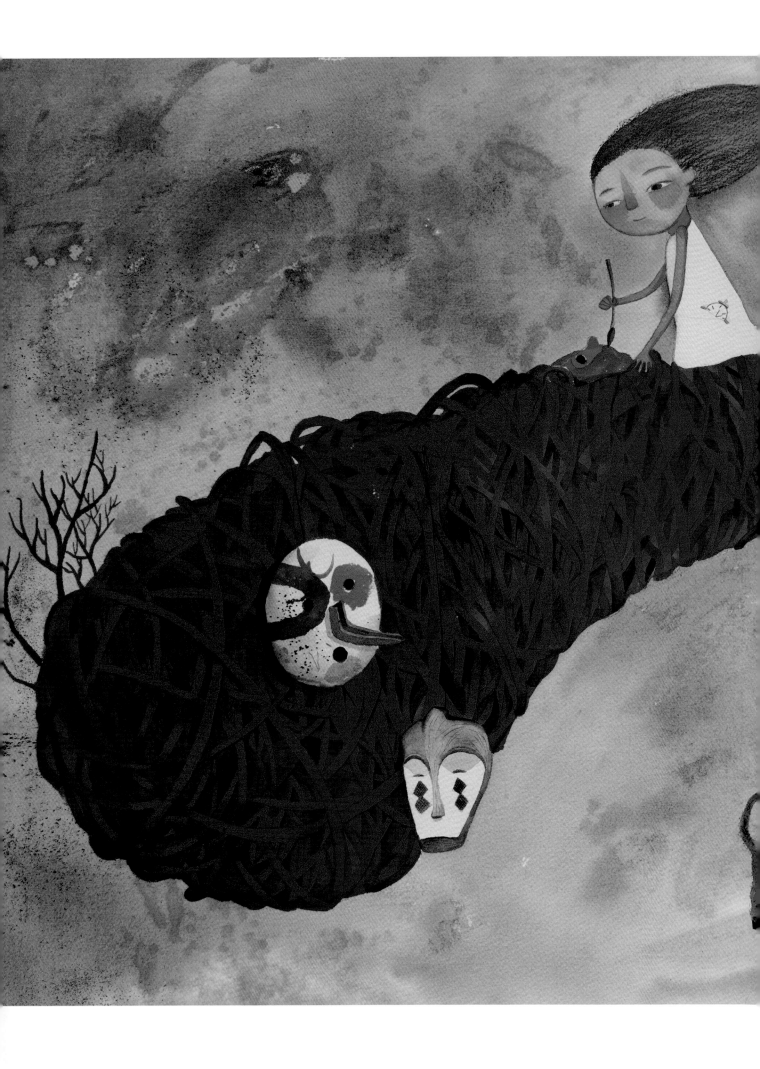

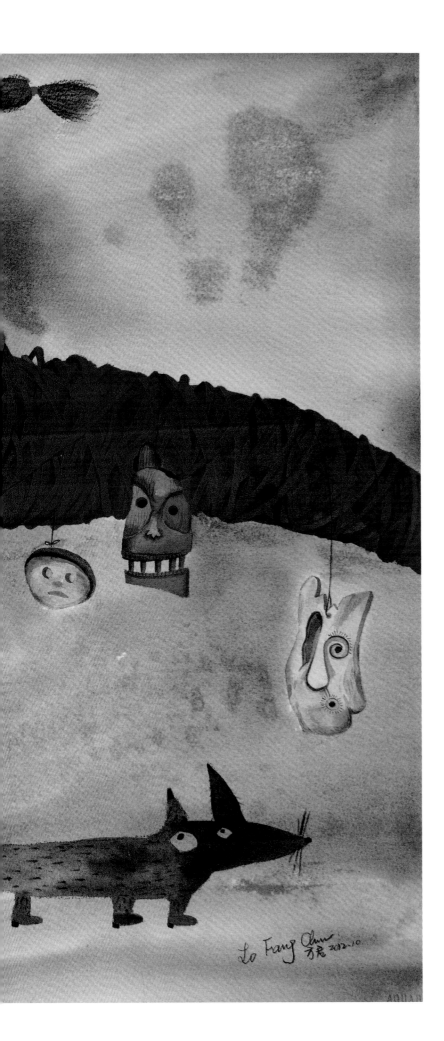

面具
Disguise
2012
2K(45cm×76cm)

水彩 油
Water color, Oil

一輩子
為他人畫了很多面具
也為自己戴了很多面具
當面具拿下之後
是否還可以辨別自己的容顏？

Over the years,
I painted numerous masks for art,
And wore many of them myself.
However, could I still recognize what's underneath once I
removed these masks?

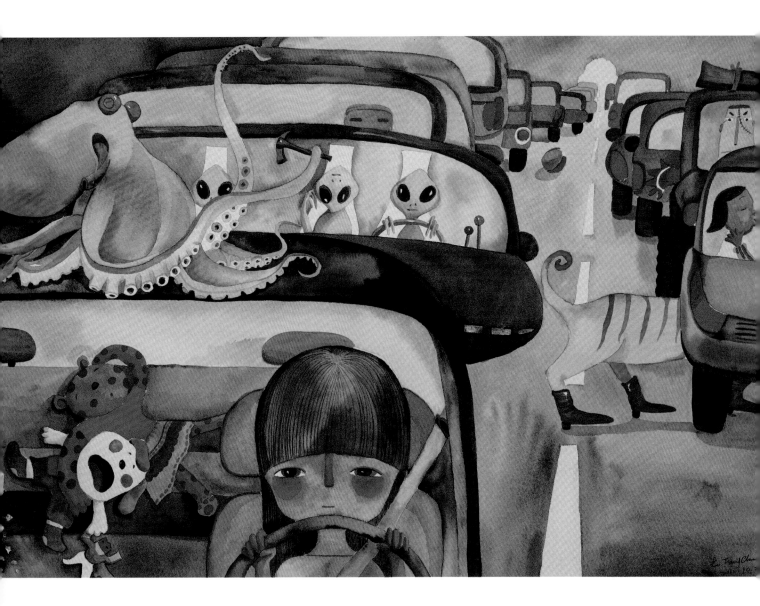

擁 擠
POPULATION OVER CROWDED
2012
4K(37cm×45cm)

水彩
Water color

荒謬的人 擁擠的世界
偏偏在同一條陌路上

In this overcrowded place,
a mob of absurd living as strangers traveling on the same road.

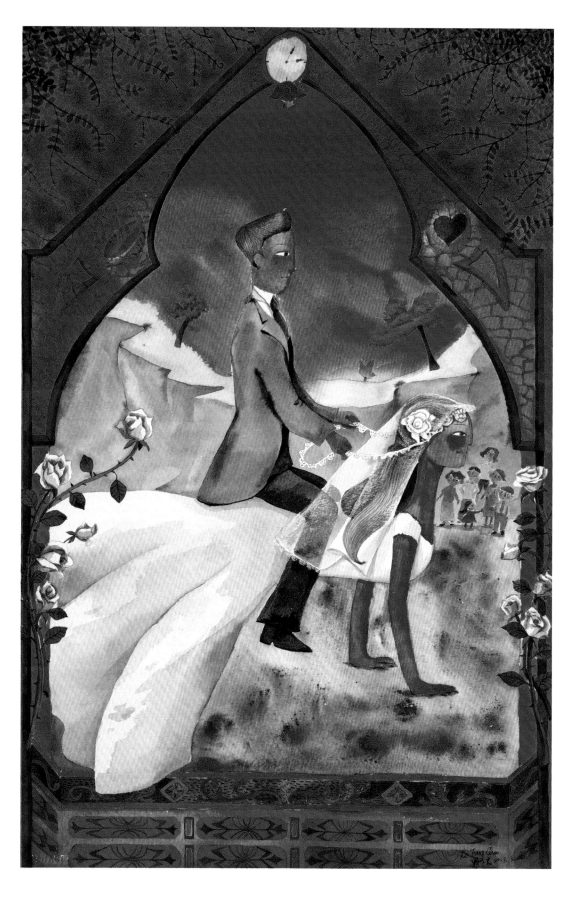

誓 約
PROMISE
2013
4K(37cm×45cm)

水彩
Water color

天老地荒 執子之手
一生一世
許下浪漫美麗的誓約

Forever holding hands,
fulfilling a promise!

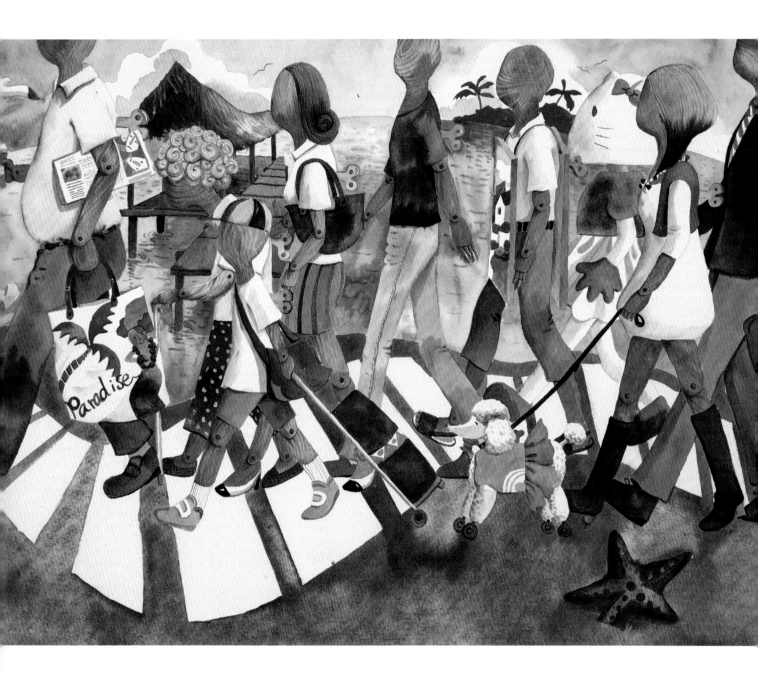

MECHANIC FIGURES
2013
4K(37cm×45cm)

水彩
Water color

時間滴答滴答
腳步踢躂踢躂
每天開不完的會
交不完的報告
木頭人啊木頭人
上緊發條 這是唯一的驅動力

Time tick-tock-tick,
Footsteps tap-tap-tap.
Endless meetings,
Endless reports,
Endless mechanical figures.

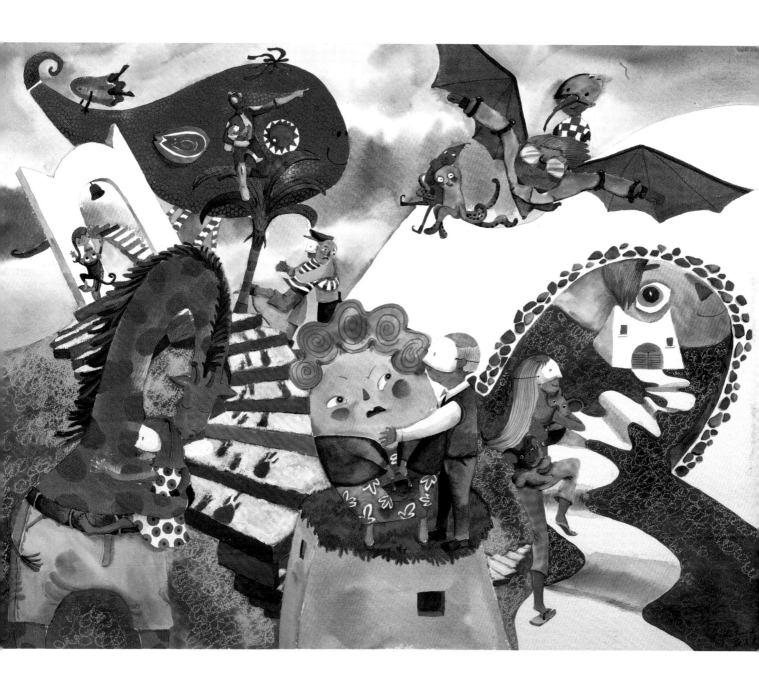

擁抱
HUG
2013
2K(45cm×76cm)

水彩
Water color

一輩子愛過很多人
有純愛 有溺愛
有真愛 也有錯愛
這些過程有喜悅 也有沮喪
但是, 別忘了 你還有擁抱的能力

We all have loved.
The innocent love,
the spoiled love,
the true love,
the unforgettable love.
Sometimes love got us hurt,
But other times it's a
joy!
So whatever it happens,
Let's start with a hug!

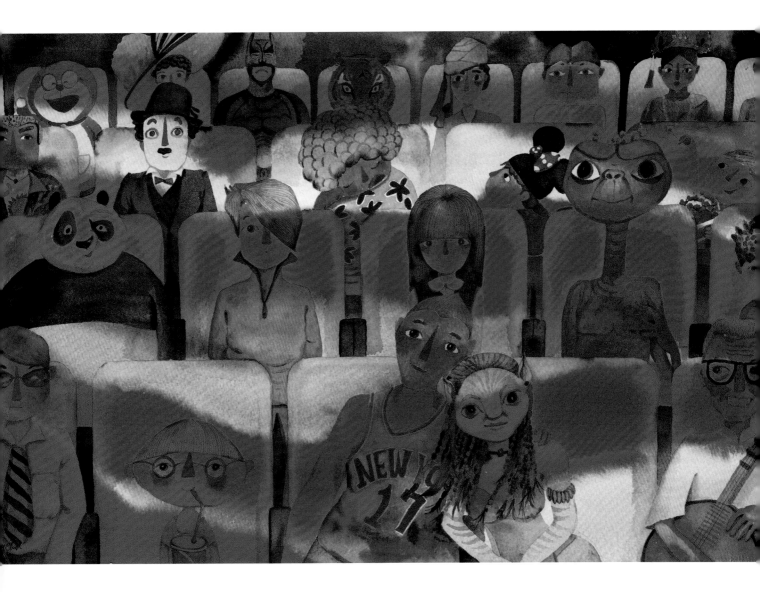

戲弄人生
THEATER
2013
4K(37cm×45cm)

水彩
Water color

看盡人生很多戲碼 但還未看透人生
無可救藥的情感投射
管他Ａ咖Ｂ咖Ｃ咖 就盡情的演吧！

I read countless scripts,
But still not yet to comprehend the script on 'life'.
Regardless of the roles I play here,
The best is yet to come!

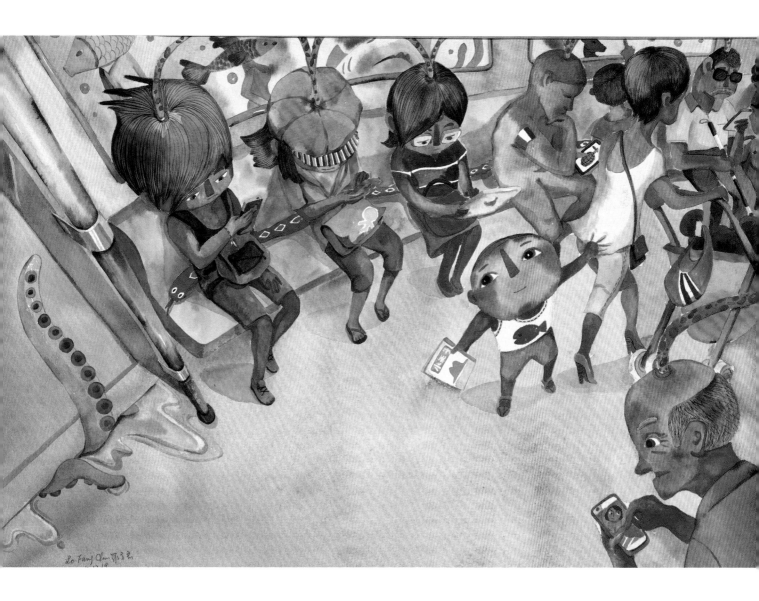

集體催眠
VIRTUAL
REALITY
SPELL
2013
4K(37cm×45cm)

水彩
Water color

我們創造了虛擬
還以為彼此更緊密
其實距離很遙遠
這是集體催眠嗎？
恐怕只有他們自己心裡才清楚

We created a virtual world linking our relationships closer to one another.
But instead, we kept drifting apart.
Are we or not under spell of this virtual reality?
Only you know the answer!

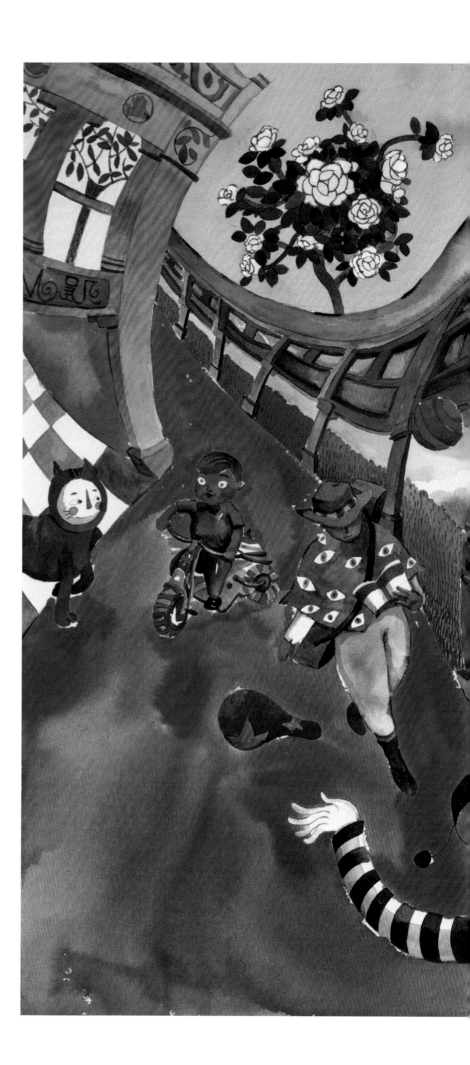

轉角
CORNER STOP
2013
2K(45cm×76cm)

水彩
Water color

老天爺開了個玩笑
在這轉角邂逅 分離
多年之後
卻又再同一個地方重逢
不知道一切是否一如往昔

Once at this corner stop,
We met, we said good-bye,
Then we ran into each other again.
After so many years,
Is God bringing back the old flames?

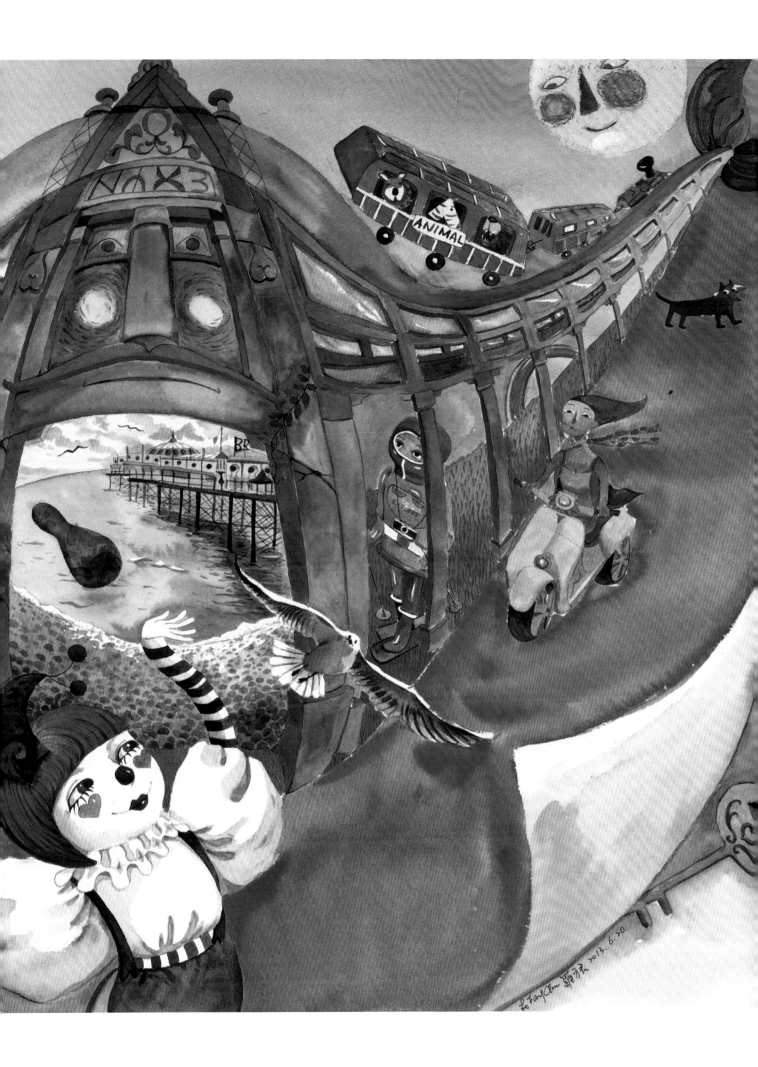

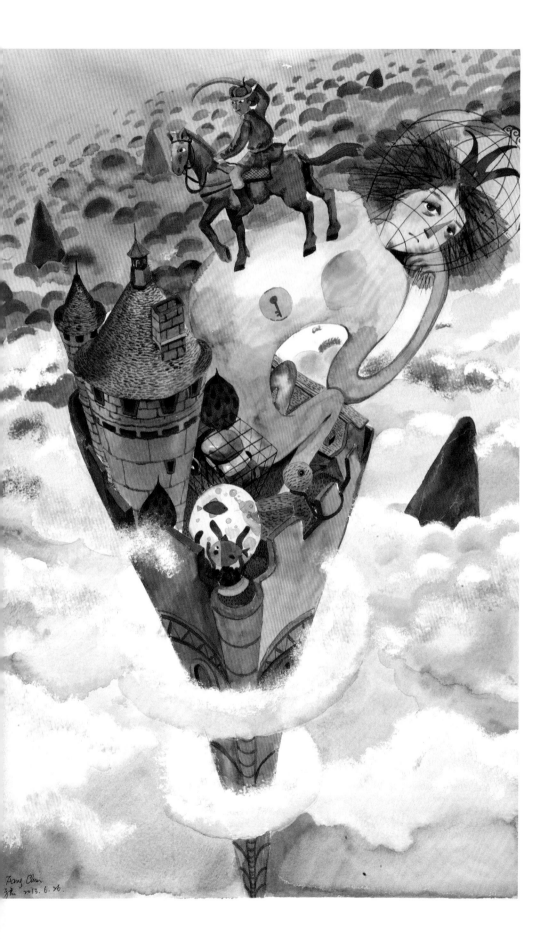

大巨人
GIANT
2013
4K(37cm×45cm)

水彩
Water color

大巨人
為自己築了一道高牆
防衛他人
卻也關閉了自己
日日夜夜 守護著
不過是那顆小小的私心

The giant built a castle
to protect himself from
villager's attacks,
but he also had boxed
himself in.
Day and night,
he's only protecting
his own little
venerable heart!

位置
FOOTHOLD
2013
2K(45cm×76cm)

水彩 蠟筆 壓克力
Watercolor, Crayons, Acrylics

大家你擠我
我擠你
不管滿不滿意
總是會有位置留給你自己
哈哈哈 大笑三聲
人生不過如此嗎？

In this overcrowded place,
we're easily being pushed aside,
yet we're still able gain a strong foothold.
Smile, because you're here!

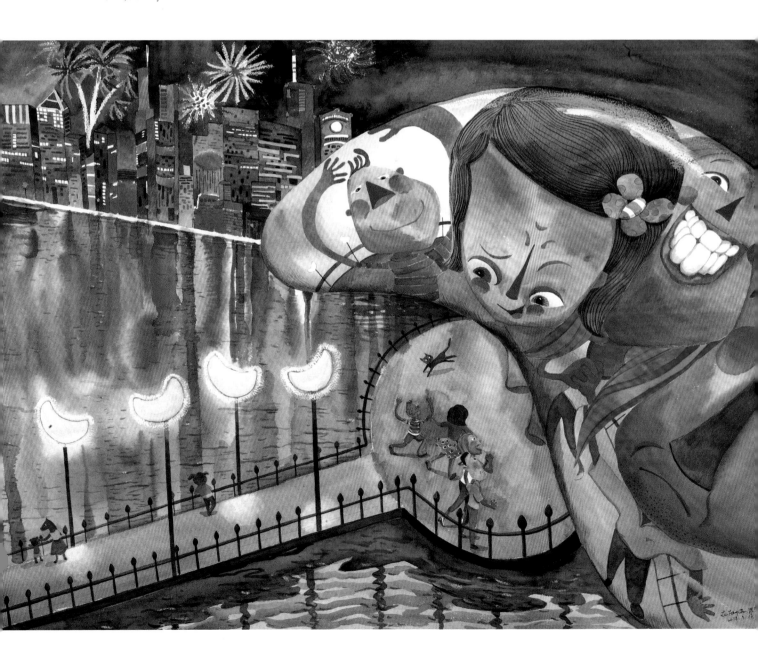

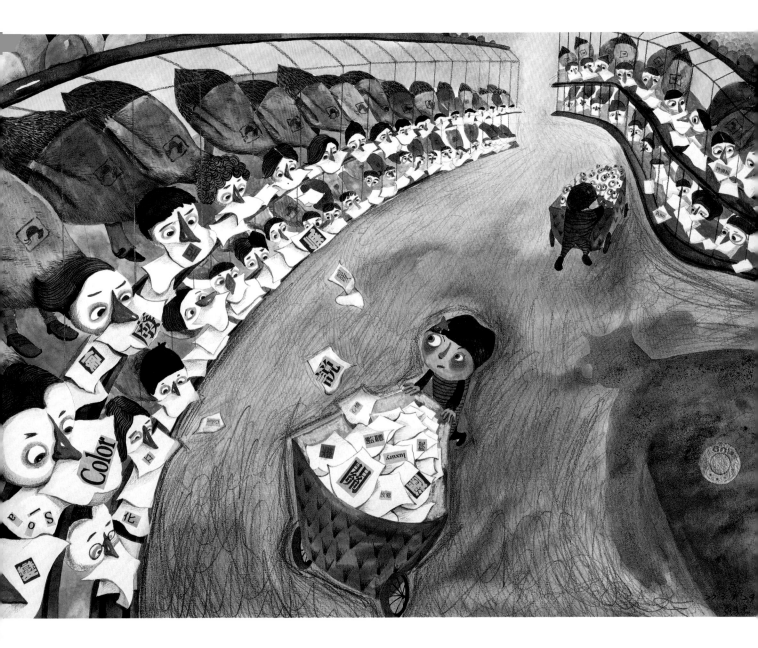

生產線上
ASSEMBLY LINE
2013
4K(37cm×45cm)

水彩 鉛筆 炭精筆 拼貼
Water color, Charcoal Pencil, Collage

制約或被制約
拼拼湊湊
誰能告訴我生活是什麼？

Are you in control or feeling lost?
Puzzle pieces for us to put together.
Who can help me to solve life's puzzles?

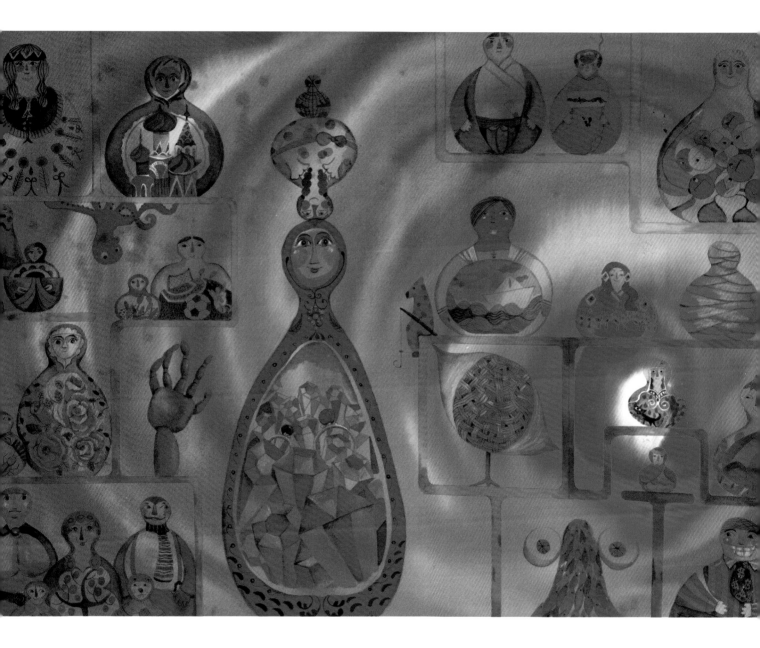

微 光
AURORA
2013
2K(45cm×76cm)

水彩
Water color

沉默是時間的外衣
就是這麼緊緊地裹住它
隱身在角落 幾乎被淡忘
慢慢地拂塵 看到微微的光

Rest comes with time.
Even being left on the shelf for ages,
and almost was forgotten.
But slowly one day,
it will see the light!

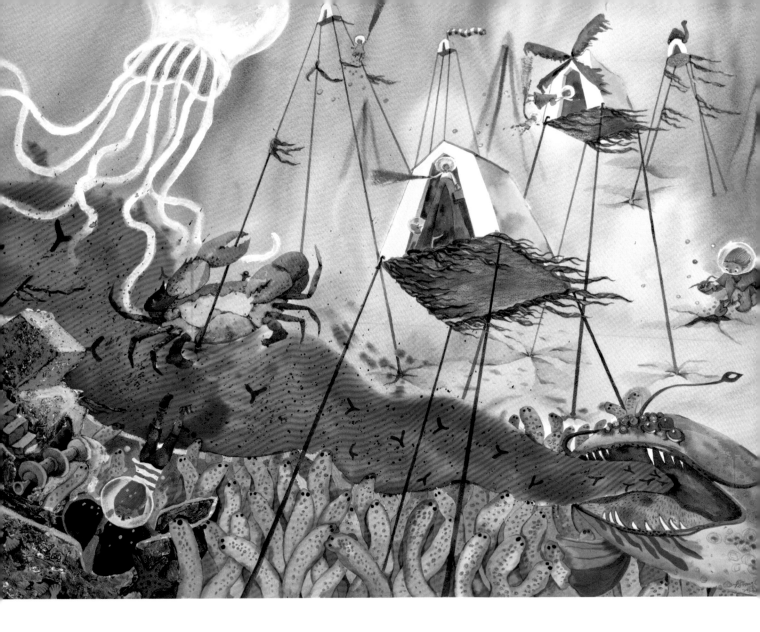

漂游國境
DRIFTING
2013
2K(45cm×76cm)

水彩 壓克力 色鉛 打底劑
Water color, Acrylic, Color, Penci Gesso

看不見藍天 聽不到風聲
也聞不到田野香
腳底下踩的 空了
徒留漂游
的國境

I can see no sky,
smell no land,
hear no wind,
and keep stepping into holes...
Drifting from places to places.

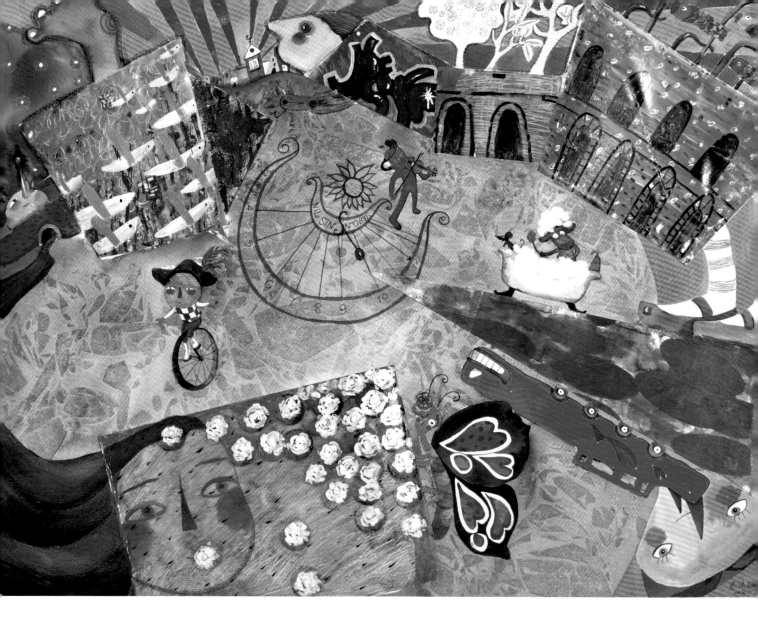

活得精彩
LIVE SHOW
2013
2K(45cm×76cm)

水彩 壓克力 色鉛 油 彩色墨水
Water color, Acrylics, Color Pencil, Oil, Liquid Watercolor

赤裸的來
孤獨的走
生命無法複製
所以 得活得精彩

Naked I come, lonely I walk. There's no way to
duplicate my performance, this is my best!

美麗的代價
PRICE TAG OF
PRIORITY
2013
2K(45cm×76cm)

水彩 壓克力顏料 彩色墨水
Water color, Acrylic, Liquid Watercolor

為了裝扮妳的美麗
我沒有選擇的權利
看得到日昇 卻等不到日落
我好想跟我的摯愛道別 只想說
真抱歉 請把我的心好好藏起來
I've been at the back seat for too long,
Waiting for your glamour to blossom.
Exhausted from waiting,
And tired of being your second priority.
I'm sorry my dear love,
It's time to say farewell.
Please forever treasure our memory

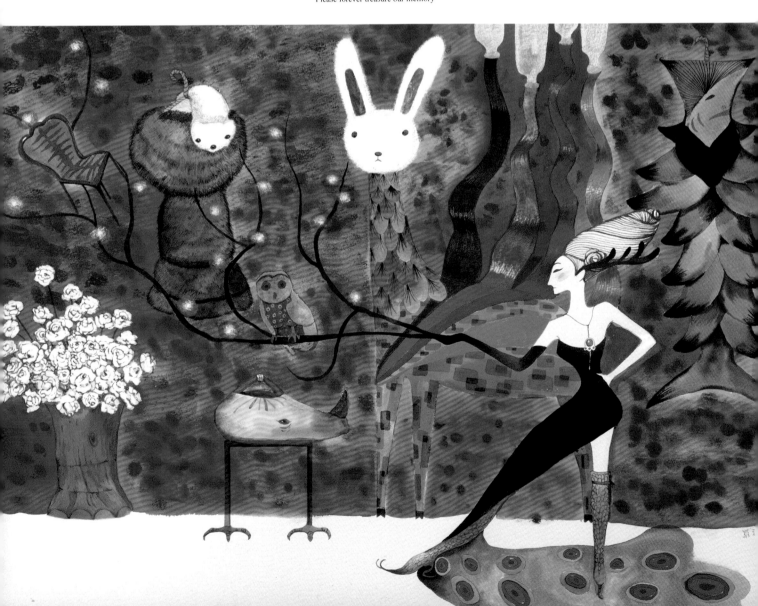

夢想的羽毛
FEATHER CAPE
2013
2K(45cm×76cm)

水彩
色鉛筆
Water Color, Pencil, Color Pencil

羽毛在鵝的身上 只是羽毛
但在你身上 可能是引領你
飛向夢想的鴻毛
所以
夢想不需要預約

The feather on the geese is just feather,
On you, it could be Superman's cape.
It'll take you to your fantasy land,
And, there's no need to make appointments.
This is your most valuable treasure,
Once you have this magic cape.

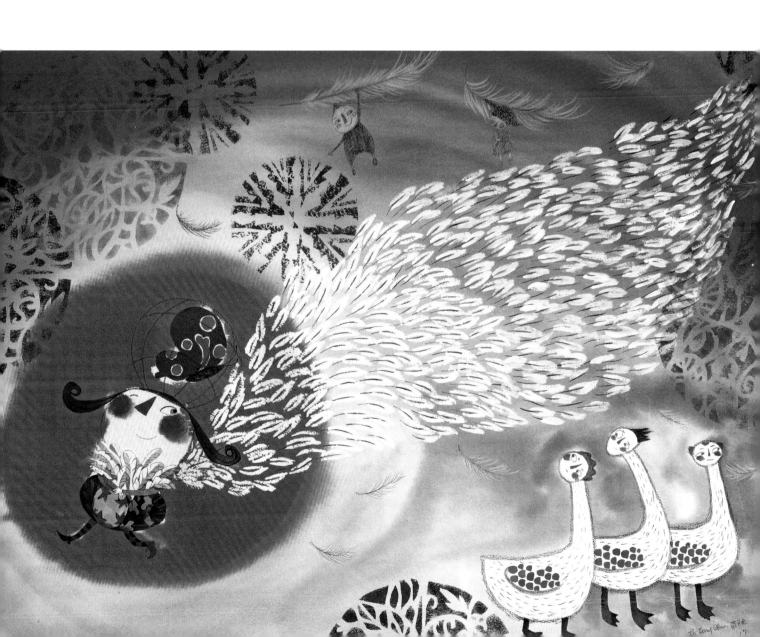

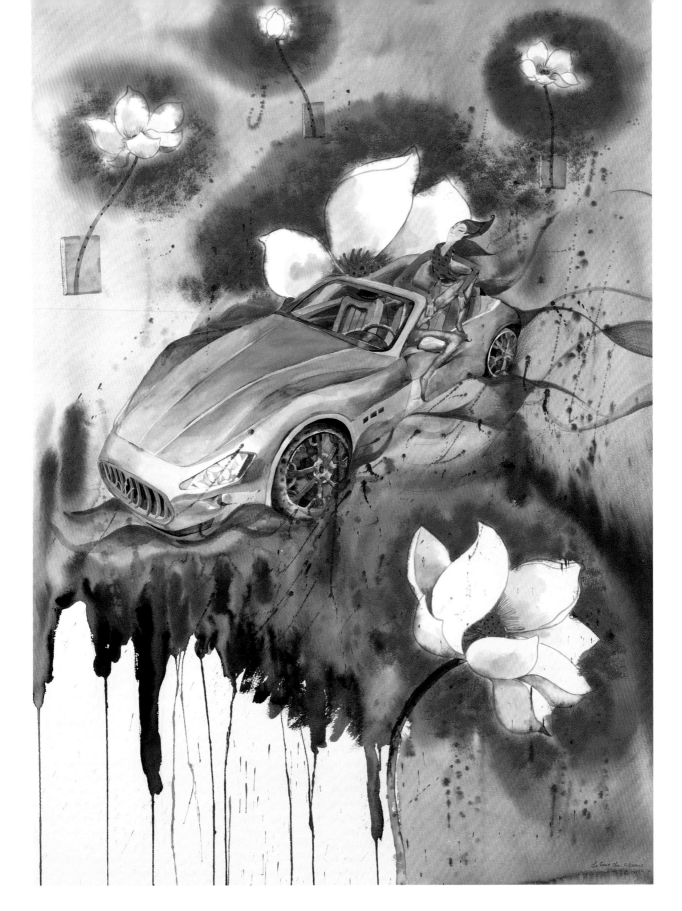

極致.淨土
LAND OF THE PURE
2014
全開(78cm×108cm)

水彩、彩色墨水
Water Color, Color ink

極致 和淨土
剎那在東西交匯
交錯出永恆的傳說

Perfection in the Land of the Pure is the Legend

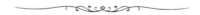

遊走他人系列
WALKING THROUGH OTHERS' ILLUSTRATIONS

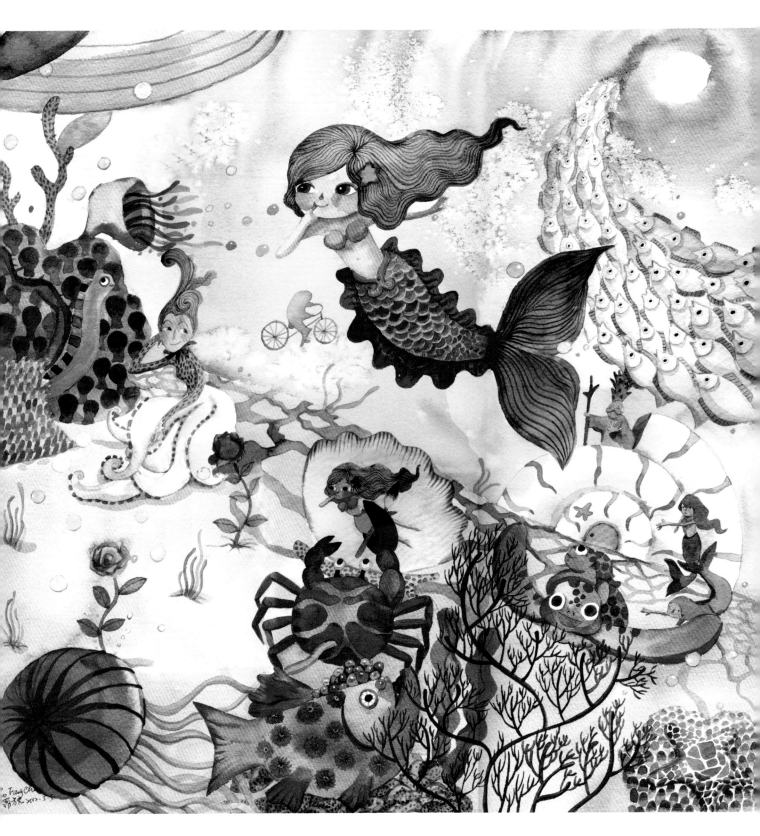

小美人魚的願望
2012
2K(45cm×76cm)

水彩

蚌殼上的美人魚有人類的雙腳
曾經擁有 終究落空
愛情猶如海底玫瑰
嚮往的美麗只放在心裡

已收藏

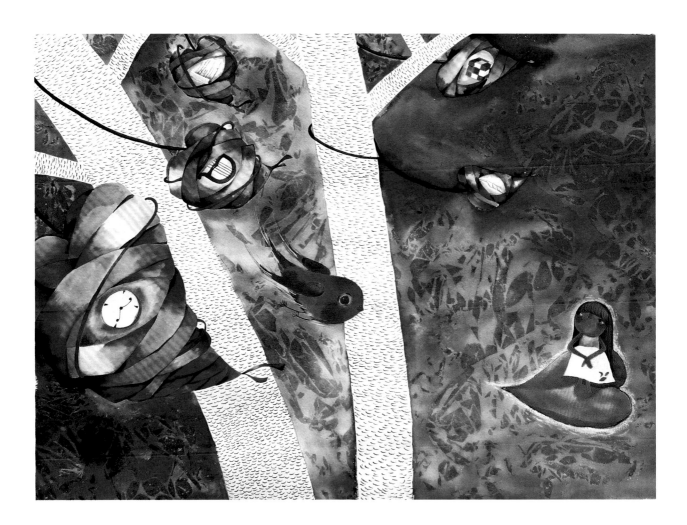

思 念
2013
2K(45cm×76cm)

水彩
鉛筆

數不盡的思念
隨著晚風飄盡
幽棉的弦律
輕輕地一聲嘆息
在 迷離的夜裡……

已收藏

美麗的相遇　　　　　　　白花雨然然灑落　　　　　　已收藏
2012　　　　　　　　　　靜謐中
4K(37cm×45cm)　　　　　聽見愛的樂章
　　　　　　　　　　　　溫暖的悸動
水彩　　　　　　　　　　茶花與音符美麗的相遇

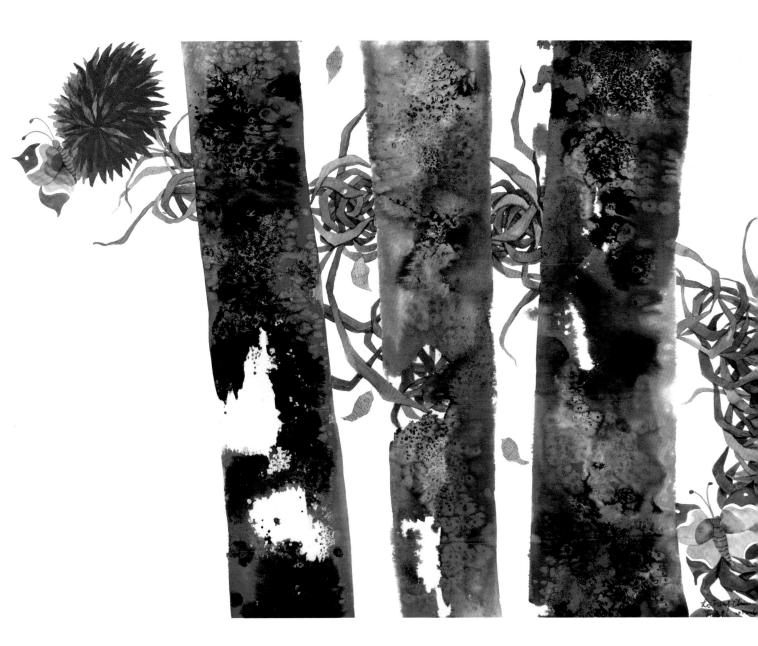

密.蜜
2012
4K(37cm×45cm)

水彩
墨汁
油

巧遇的邂逅
殘影片片 浮生若夢
巨大的花
破繭而出的蝴蝶
是否流連那份糖蜜般的美麗

已收藏

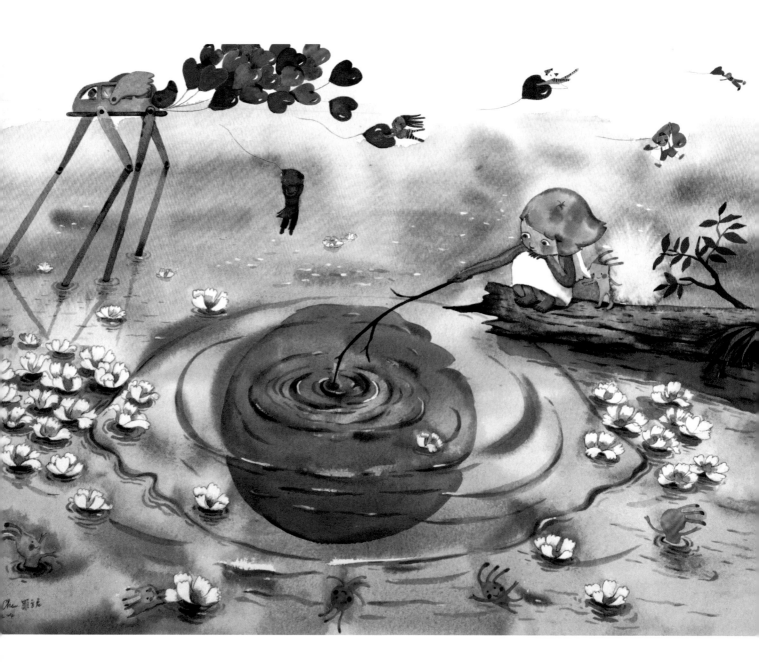

天使的眼睛　　　　　　　感恩的眼睛　　　　　　已收藏
2013　　　　　　　　　　美麗的大眼睛
4K(37cm×45cm)　　　　 三歲即將失去的眼睛
　　　　　　　　　　　　天使的眼睛
水彩　　　　　　　　　　洗滌痛苦
　　　　　　　　　　　　小眼睛化為萬花筒
　　　　　　　　　　　　帶給所有社會上需要關懷的人
　　　　　　　　　　　　一個美麗大世界

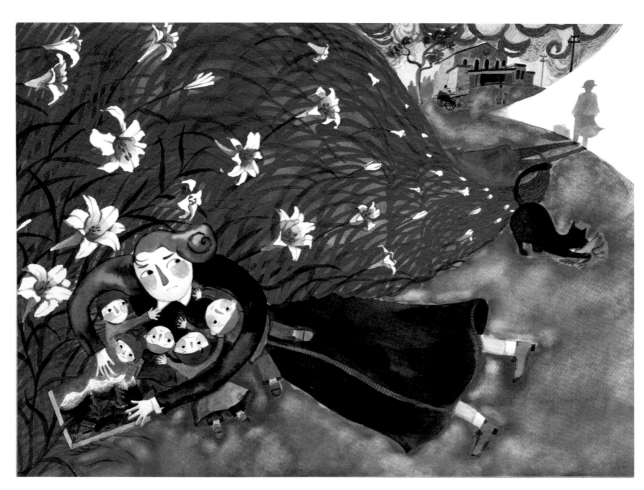

藏畫的女人
2013
4K(37cm×45cm)

水彩

張捷女士 沉默寡言
編織著愁苦 隻身肩負家計
保全陳家血脈 就憑著'咱做天看'
讓大畫家的作品得以讓後人傳誦
做一個'藏畫的女人'

已收藏

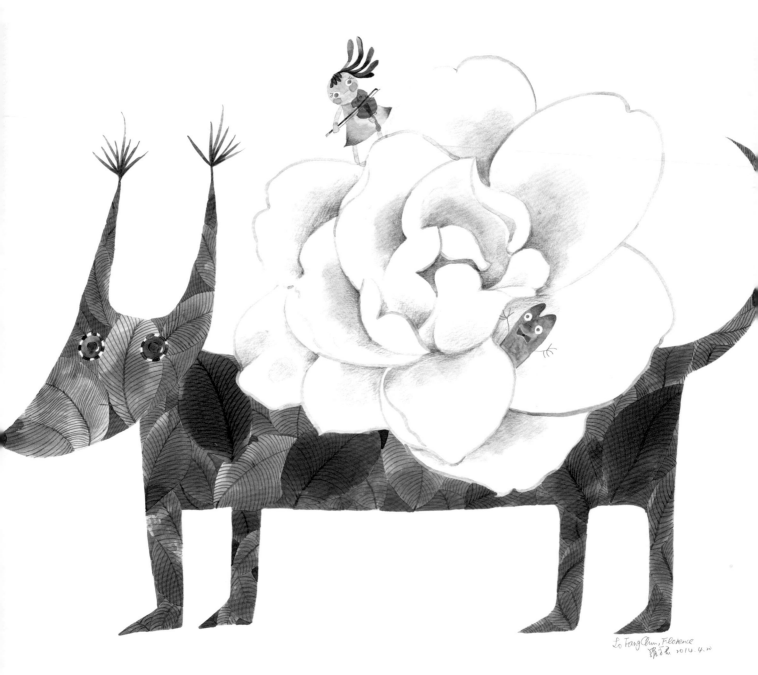

茶花與狗
Camellia And The Puppy
2014

水彩 色鉛筆

茶花代表曾經擁有的美麗
現在代表重生與希望

已收藏

Camellia represents the beauty from the past;
The Present represents the reborn and hope.

特別感謝一路支持我的家人、師長、同窗、好友和何歡劇團與豐群汽車的贊助

*Email:beauty.losky@gmail.com
*彩繪希望工作室 http://www.facebook.com/PaintedHopeArtStudio
*www.heyshow.com/browsing/21498

插畫家｜羅方君 Florence Lo
設計｜一瞬・蔡南昇
企編｜黃婷 Ting Huang
攝影｜劉和讓 Hojang Liu
翻譯｜Nina Ediwards, 竇道平 Tom Tui
印刷｜華尚龍印刷有限公司 WHA SUN LONG DESIGN PRINTING CO.,LTD.